Ellsworth Kelly
Colors for a Large Wall

JODI HAUPTMAN

THE MUSEUM OF MODERN ART, NEW YORK

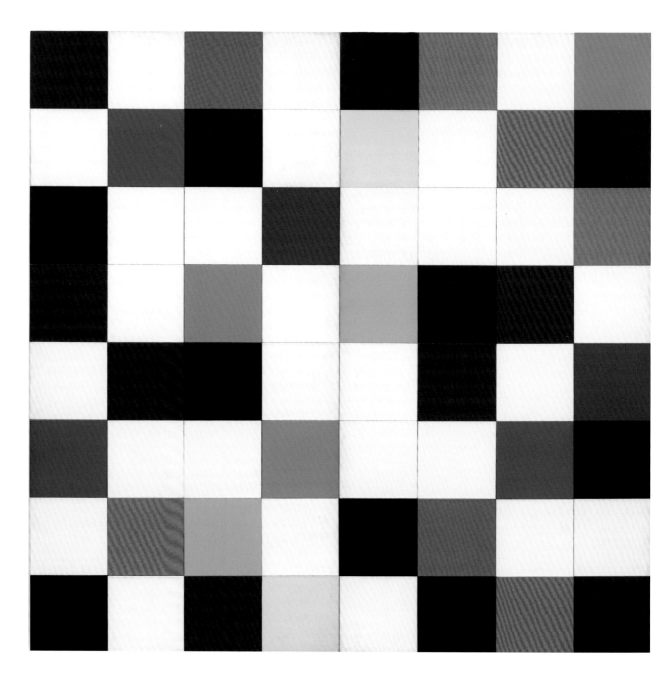

Ellsworth Kelly (American, 1923–2015). *Colors for a Large Wall.* 1951. Oil on canvas, sixty-four panels, 7' 10½" × 7' 10½" (240 × 240 cm). THE MUSEUM OF MODERN ART, NEW YORK. GIFT OF THE ARTIST

ELLSWORTH KELLY'S COMMITMENT TO CLOSE LOOKING BEGAN IN THE COMPANY OF birds. Born in Newburgh, New York, in 1923 and raised in Oradell, New Jersey, Kelly was often sick as a child; in the hope of getting him outdoors, his mother and grandmother introduced him to bird-watching. "Color fascinated me in birds—red streak here, blue streak there, green streak here," he reminisced. "I feel that the freedom of colors in space is very much what I've always been involved in."[1] "I believe my early interest in nature taught me how to 'see.'"[2]

His childhood lessons in the focused observation of nature were deepened through other foundational experiences, from art school—first at Pratt Institute in Brooklyn, New York, where he was introduced to color theory, and later at the School of the Museum of Fine Arts, Boston—to his years in the US Army during World War II, where he served in the 603rd Engineer Camouflage Battalion [FIG. 1]. "Working with camouflage meant working with perception," Kelly explained. "I've always been interested in perception—as a visualist, a lot of my work is about understanding what I see."[3] Throughout his seven-decade career as an artist, looking was the crucial thread.

Today Kelly is celebrated for his unique investigations of shape and color [FIG. 2]. Unique because his famed canvases of bold flat color presented in stark geometries stood in sharp contrast, when they first appeared in the early 1950s, to the reigning approach of Abstract Expressionism, with its gestural strokes and dripped paint said to express the interiority of their maker. Unique because even when his seemingly simple shapes rhymed with the streamlined forms of Minimalism in the 1960s, Kelly's approach had a very different motivation. His singular vision was rooted in close, empirical observation of the world. Whether the tile pattern in the shower, the outline of trees against a bright sky, or a multihued sign on the street, Kelly mined everyday shapes and colors as the raw materials for his paintings, drawings, sculptures, prints, and photographs. Learning from Kelly how humble elements in our environment can be transformed—the area under a bridge and its reflection in the water become an eye-catching geometry of two joined arcs; shadows from a metal staircase yield

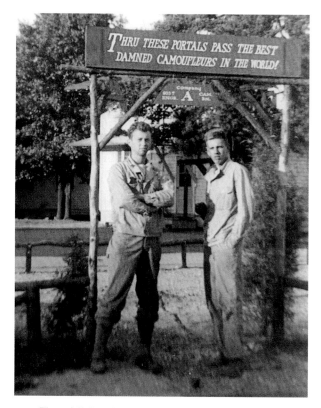

FIG. 1. Ellsworth Kelly with Elmer Mellebrand, Fort Meade, Maryland, 1943

a panorama of jagged angled lines [**FIGS. 3, 4**]—pays enormous dividends to his viewers, encouraging what the artist calls "eye-work."[4] It is indeed work to notice these patterns, fragments, and forms, but it is a labor of generosity and an openness to the potential and possibilities of the built and natural worlds.

An artist of the same generation as Jasper Johns, Joan Mitchell, Claes Oldenburg, and Robert Rauschenberg, Kelly insisted that "all artists have to learn how to see."[5] Much of his learning, his journey to maturity as an artist, occurred in France, between 1948 and 1954. After two years at art school in Boston, he took advantage of the GI Bill to return to Paris, which he had first seen as a soldier in 1944, shortly after the Liberation.[6] Ultimately, Kelly's education in seeing resulted in a rupture with traditions of artmaking both old and new and led to his breakthrough painting *Colors for a Large Wall* (1951). This is the story of that painting.

———

One of Kelly's first stops after he returned to Paris in October 1948 was the small town of Colmar in eastern France, close to the German border. He made that

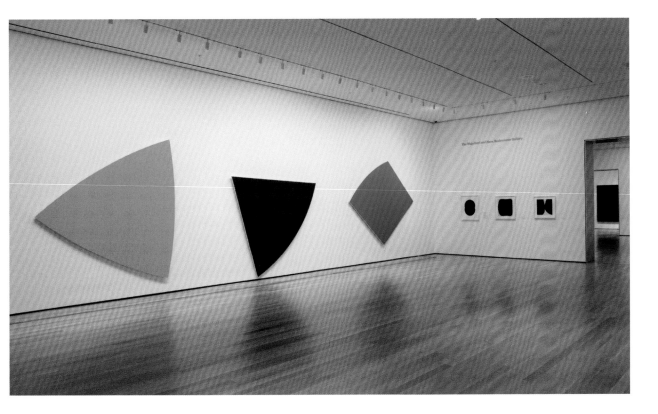

FIG. 2. Ellsworth Kelly (American, 1923–2015). *Three Panels: Orange, Dark Gray, Green.* 1986. Oil on canvas, three panels; overall: 9′ 8″ × 34′ 4½″ (294.6 × 1047.7 cm). THE MUSEUM OF MODERN ART, NEW YORK. GIFT OF DOUGLAS S. CRAMER FOUNDATION

FIG. 3. Ellsworth Kelly (American, 1923–2015). *Study for White Plaque: Bridge Arch and Reflection*. 1951. Cut-and-pasted colored paper on paper, 20¼ × 14¼" (51.4 × 36.1 cm). THE MUSEUM OF MODERN ART, NEW YORK. GIFT OF THE ARTIST IN HONOR OF MR. AND MRS. JOSEPH PULITZER, JR.

FIG. 4. Ellsworth Kelly (American, 1923–2015). *La Combe I*. 1950. Oil on canvas, 38 × 63¹¹⁄₁₆ " (96.5 × 161.8 cm).
WHITNEY MUSEUM OF AMERICAN ART, NEW YORK. GIFT OF THE AMERICAN CONTEMPORARY ART FOUNDATION, INC.,
LEONARD A. LAUDER, PRESIDENT

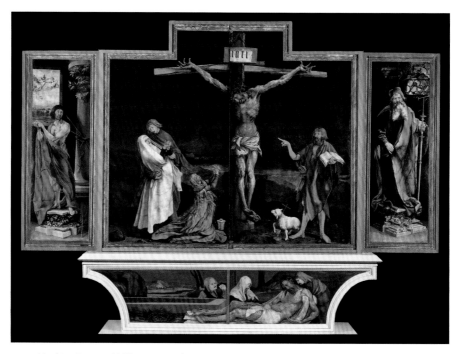

FIG. 5. Matthias Grünewald (German, 1475/80–1528). Isenheim Alterpiece (closed). 1512–16. Oil and tempera on wood panels, central panel: 8′ 9⅝″ × 10′ (269 × 307 cm), wings: 7′ 6⅜″ × 29½″ (232 × 75 cm). MUSÉE D'UNTERLINDEN, COLMAR, FRANCE

cross-country trip to see the Isenheim Altarpiece (1512–16; **FIG. 5**), a monument of the early sixteenth century he knew from a school research project. Matthias Grünewald painted the altarpiece's multiple panels for the hospital chapel at the Monastery of Saint Anthony, an order that ministered to those suffering from ergotism, an agonizing, gangrenous fungal infection. With its tormented and diseased figure of Christ—tendons stretched, hands splayed, torso blistered—its saints and mourners in various degrees of bodily grief, and its costumes and background a vibrant juxtaposition of red-orange and blue-green, the altarpiece was for Kelly "related in [its] . . . expressionist technique to Picasso and Beckmann, the two artists I most admired at that time."[7] It is striking that Kelly's postwar years in France would begin here in front of one of the most excruciatingly visceral representations of bodies in distress and culminate in the aspiration to eliminate all expression, figuration, personality, and invention from painting. For in those years, according to Yve-Alain Bois—the preeminent scholar of the artist's work—Kelly developed a resolve to "make a painting without having to invent a composition, without having to involve his subjective taste or agency, without having to decide where to place things and in which order on his canvas."[8] The artist says it plainly: "I felt I didn't want to invent."[9]

Kelly's dismissal of invention was, paradoxically, articulated during what was for him an extraordinarily inventive period: a time marked by the development of a series of approaches to making art that would ultimately define his entire career. *Colors for a Large Wall*, completed in December 1951, three years after his visit to Colmar, is the capstone of that moment. Not only the largest work that Kelly made up until that time, it also fully encompassed the artist's new language and methods. *Colors* is constructed from sixty-four square panels that together form an almost eight-by-eight-foot square. Each panel is painted flatly and exactly—completely devoid of gesture—in one of fourteen colors. An armature on the work's back joins and secures the panels, but Kelly wants us to observe that the work is constructed from multiple elements, and, to that end, the junctions between each square are clearly visible. As for the work's colors, sometimes white and black panels are adjacent, but there is no adjacency among any of the other hues, whether in the grid's vertical, horizontal, or diagonal vectors. As we look at the entire work or examine it part by part, from one color to the next, no recognizable pattern is discernable, making it seem that the panels could be easily rearranged at will, a game offered up for our pleasure. This is not the case, however. Once Kelly settled on this order—via a collage study—it was set. No rearranging. And just as the title of the work refers to it being made "for a large wall," the work is enveloping, filling our visual field with dynamic, colorful rhythm, a syncopation that feels almost musical in its bounce and beat.

In describing *Colors for a Large Wall* and his approach to creating it, Kelly explains less what it is than what it isn't, what he refused to do: "I was deciding what I didn't want in a painting, and just kept throwing things out—like marks, lines, and the painted edge."[10] Figuration, emotion, depiction, gesture, and composition also ended up in the trash heap. How, then, did a move *against* creativity, against invention, against reason, against an "autographic, gestural 'self,'"[11] yield one of the greatest works of the postwar period?

——

Kelly's refusals, his instinct to remove, reduce, and excise, resonated with a tendency in postwar Europe to pare down, to "begin again from scratch," to borrow the words of the French philosopher Jean-Paul Sartre.[12] Across disciplines and across the political spectrum, the devastation of World War II—from the material to the moral—provoked the urgent question, How can one move forward, how can one make art in the wake of Auschwitz and Hiroshima without being complicit in that barbarism? This "degree zero"—or simply "zero"—aspired or referred to by so many artists, writers, filmmakers, composers, and philosophers in those postwar years (including Roland Barthes, Saburo Murakami, and Roberto Rosselini, to name just three) was a crucial context in which Kelly's fledgling practice began.

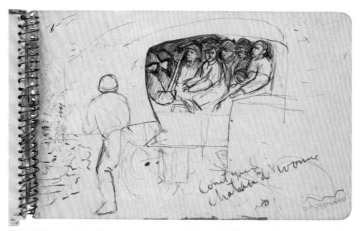

FIG. 6. Ellsworth Kelly (American, 1923–2015). *Young Soldiers Being Transported to the Front, Remagen, Courtyard, Château de Divonne, France* (from Sketchbook #2). 1945. Ink on paper, 5¼ × 8¼" (13.3 × 21 cm). COLLECTION ELLSWORTH KELLY STUDIO AND JACK SHEAR

Bois enumerates a set of reasons specific to Kelly to explain his drive for an art devoid of invention.[13] Like many artists, Bois argues, Kelly wrestled with how to be an "author" in the context of the recent war's unprecedented inhumanity. As a private in the US Army, Kelly experienced that inhumanity directly: he landed in Normandy only weeks after the first wave of the Allied invasion, drove supplies across war-ravaged France, and had to beat a hasty retreat from Luxembourg City at the onset of the bloody Battle of the Bulge; after the German surrender, his battalion was responsible for guarding Displaced Persons camps populated by the sick, the starving, and the psychologically traumatized. Perhaps most poignantly, in early 1945 he transported a group of new recruits to the German front at the time of the pivotal Battle of Remagen. Before he headed out with the convoy, Kelly made a quick sketch of the soldiers crouched together in the back of the truck, overcome with fearful anticipation and dread **[FIG. 6]**. After dropping them off "under a night sky . . . pink with shell flashes," Kelly learned that they had been massacred at first fire.[14]

Another reason for rejecting invention, Bois tells us, is related to Kelly's interest in the labor of other kinds of makers. The work of anonymous craftsmen and members of medieval guilds whose names are lost to history—stonemasons, mosaicists, sign painters, for example—was far more interesting to Kelly than the achievements of renowned individuals, making an explicit or forthright expression of authorship unimportant to his own practice. Finally, as much as Kelly admired Pablo Picasso, the older artist was also an overwhelming force to be reckoned with, looming large over generations of up-and-coming painters, sculptors, and printmakers. "If you started out by erasing yourself, your personality, your genius,"

Bois writes, "nobody would be able to come and say that Picasso did it better."[15] Kelly asked himself, "What am I going to be? A tenth-rate Picasso?"[16]

Kelly's rejection of figuration and representation, his reductions of shape and form, his quest for a way to make art without individual expression, was at the same time an embrace of a series of alternatives, means that together would enable the creation of *Colors for a Large Wall*. Bois identifies four key strategies in Kelly's anti-compositional approach: setting aside creative composing in favor of accepting something already made, an element out there in the world; abandoning choice in favor of chance; taking up the grid as an organizing system or principle; and embracing the monochrome, a painting made with a single color.[17] In addition to these strategies, Kelly developed a deep and abiding attentiveness to the relationship between artwork and wall, art and architecture. These methods and interests were not completely novel on their own—other artists of Kelly's own and earlier generations had launched similar investigations. But Kelly's distinctive move, what came to define his practice during those years in France, was to use them in combination.[18] Over the course of three years, Kelly took up each approach, sometimes with one prompting the next. This may seem to imply that his path was foreordained or perfectly smooth; however, the evolution of Kelly's process is better described as a series of starts and stops, advances and detours.

———

In addition to his trip to Colmar in 1948, Kelly made pilgrimages to "as many sites of Romanesque architecture as he could," recording his trips to such locales as Poitiers and Tavant (both with significant churches) by checking off the items on a carefully planned inventory of monuments that he was determined to see.[19] Soon, however, "just the way things looked here in Paris" became of supreme interest, and he filled his notebooks with drawings of ordinary urban structures, from grates embedded in streets and sidewalks to chimneys traveling down stone walls [FIG. 7], "things made by carpenters, masons."[20] "It is here [in Paris] that I started really noticing things and working on what I was seeing."[21] Learning to look anew would be entirely transformative: "I became more interested in the physical structure of Paris, the stonework and the old bridges, and preferred to study and be influenced by it rather than by contemporary art. The forms found in the vaulting of a cathedral or a splatter of tar on a road seemed more valid and instructive and a more voluptuous experience than either geometric or action painting."[22] A focus on the minor, the everyday, and the detail perhaps offered Kelly a way to counter the enormity and trauma of the recent war, a way to redeem a fallen world.

Looking eventually led to creating, though instead of "making a picture that was an interpretation of a thing seen, or a picture of *invented content*," Kelly explains, "I found an object and presented it as itself alone. The first of the object-oriented works was *Toilette* [FIG. 8], which was derived from a particularly French

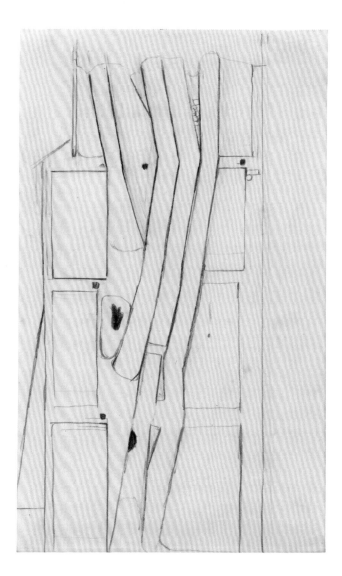

FIG. 7. Ellsworth Kelly (American, 1923–2015). *Chimney Patterns III*. 1949. Pencil on paper, 17⅛ × 10⅛″ (43.5 × 25.7 cm). COLLECTION ELLSWORTH KELLY STUDIO AND JACK SHEAR

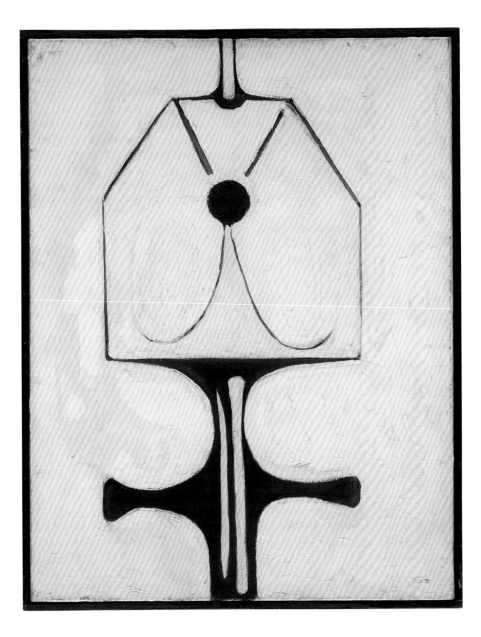

FIG. 8. Ellsworth Kelly (American, 1923–2015). *Toilette.* 1949. Oil on canvas with painted wood frame, 24¾ × 18¾ × ½″ (62.9 × 47.6 × 1.3 cm). COLLECTION ELLSWORTH KELLY STUDIO AND JACK SHEAR

FIG. 9. Ellsworth Kelly (American, 1923–2015). *Wall II, rue Saint-Louis en l'Île, Paris.* 1950, printed 2015. Gelatin silver print, 13 × 8⅜" (33 × 21.3 cm). SAN FRANCISCO MUSEUM OF MODERN ART. GIFT OF THE ARTIST

design of a floor toilet, which only Parisians and visitors to Paris will recognize."[23] Kelly moved through the city as if he were a human viewfinder, cropping elements and then rendering them exactly as he saw them—an exactitude that also made these subjects seem strange or unfamiliar. "I think if you can turn off the mind and look at things only with your eyes, ultimately everything becomes abstract."[24] Examples of that looking and cropping—that abstraction—can be seen in the many photographs Kelly made of his urban discoveries **[FIG. 9]**.[25] Things in the world that only Kelly might notice—views that the rest of us will likely walk right by—were found outside the city too. "I did a painting of a kilometer marker," Kelly once remarked. "And unless you are aware of what a kilometer marker looks like, it's just an abstract shape" **[FIG. 10]**.[26]

An interest in what he called the "object quality" of things soon led to the creation of actual objects. Kelly describes this pivotal moment:

FIG. 10. Ellsworth Kelly (American, 1923–2015). *Kilometer Marker*. 1949. Gesso, graphite, and oil on wood, 21½ × 18 × 1½″ (54.6 × 45.7 × 3.8 cm). SAN FRANCISCO MUSEUM OF MODERN ART. THE DORIS AND DONALD FISHER COLLECTION AT THE SAN FRANCISCO MUSEUM OF MODERN ART, THE MIMI HAAS COLLECTION, AND PROMISED GIFT OF HELEN AND CHARLES SCHWAB

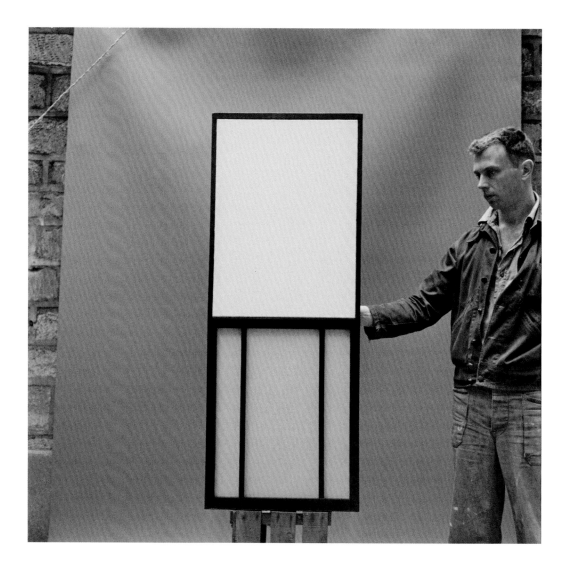

FIG. 11. Ellsworth Kelly with *Window, Museum of Modern Art, Paris* (1949), Paris, November 1949

In November or December of 1949 I saw an exhibition at the Musée d'Art Moderne in Paris. The paintings were small. But the windows! I suppose the windows were fifteen feet high. The bottom half of the window was divided into three vertical panes. The top pane was clear glass and you saw sky through it. There was a metal frame around each of the panes. This window interested me much more than the paintings did. So I made a drawing of it. Several drawings. Then I went to the studio and constructed it.[27]

Kelly's building blocks were two canvases, one facing forward and smoothly coated in white paint; the other, flipped to its reverse side to reveal its stretcher bars, is similarly painted in gray. Wood strips encase the stacked canvases and, along with the visible stretcher bars and two additional vertical rods, demarcate the window's frame and mullions, resulting in a correspondence of subject and means. A painting and an object, a depiction and a model, *Window, Museum of Modern Art, Paris* [FIG. 11] was Kelly's first step away from traditional painterly representation while still remaining completely connected to the world around him. "From then on painting as I had known it was finished for me," Kelly declared. "The new works were to be objects, unsigned, anonymous. Everywhere I looked, everything I saw became something to be made, and it had to be exactly as it was, with nothing added. It was a new freedom; there was no longer the need to compose."[28] Such close looking at the city offered Kelly a path away from depiction and representation—the first step toward *Colors for a Large Wall*.

———

Works like *Kilometer Marker* and *Window, Museum of Modern Art, Paris* proved to Kelly that a composition did not have to spring out of his head, that invention was not an essential element in creation. But he wanted to further remove himself, to eliminate conscious choice from his process. Chance offered a solution: whether by drawing with his eyes closed; composing by letting bits of paper fall from a distance to a surface; or making decisions by picking colored squares out of a hat. Kelly was not the first artist to use chance to bypass personal decision-making. These methods had been widely embraced earlier in the twentieth century. Having experienced the suffering and destruction of World War I, artists associated with Dada in the 1910s, for example, lost faith in the utility of rational thought, leading many to adopt chance procedures, processes that seemed to perfectly match an era lacking reason. Less than a decade later, the Surrealists followed suit, seeing that chance might be a way to tap into the unconscious mind. Automatic drawing—drawing without the guidance of a preconceived composition—for example, seemed to provide a direct line from mind to hand, without the intervention of one's ego [FIG. 12].

FIG. 12. André Masson (French, 1896–1987). *Automatic Drawing.* 1924. Ink on paper, 9¼ × 8 ⅛"
(23.5 × 20.6 cm). THE MUSEUM OF MODERN ART, NEW YORK. GIVEN ANONYMOUSLY

Kelly knew of these approaches and had begun to experiment with them
with keen interest beginning in February 1950 [**FIG. 13**], but central to his
engagement with chance were encounters that same year with the practices
of Dadaists Jean Arp and Sophie Taeuber-Arp, both of whom had deployed
similar methods.[29] For one of his best-known works, Arp had torn paper into
squares and then, from a distance above, dropped each onto a sheet of paper.
Gluing the squares down where they landed, Arp allowed gravity to author his

FIG. 13. Ellsworth Kelly (American, 1923–2015). *Automatic Drawing: Pine Branches VI*. 1950. Pencil on paper, 16 ½ × 20 ¼" (41.9 × 51.4 cm). THE MUSEUM OF MODERN ART, NEW YORK. GIFT OF THE ARTIST

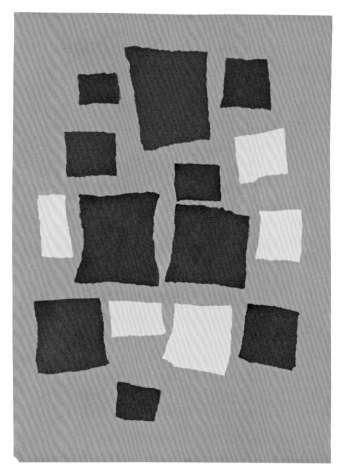

FIG. 14. Jean (Hans) Arp (French, born Germany [Alsace]. 1886–1966). *Untitled (Collage with Squares Arranged according to the Law of Chance)*. 1916–17. Torn-and-pasted paper and colored paper on colored paper, 19⅛ × 13⅝" (48.5 × 34.6 cm). THE MUSEUM OF MODERN ART, NEW YORK. PURCHASE

composition—for instance, *Untitled (Collage with Squares Arranged according to the Law of Chance)*, 1916–17 **[FIG. 14]**. Kelly made "scores of works on paper during the summer and fall of 1950 inspired by Jean Arp's collages."[30] In one of these, *Cut Up Drawing Rearranged by Chance* **[FIG. 15]**, Kelly tried out what he learned from Arp: "I began making my own chance collages. Although similar in spirit to those of the Arps, their squared component shapes were regular in size and ordered in predetermined rows. The element of chance was introduced in the

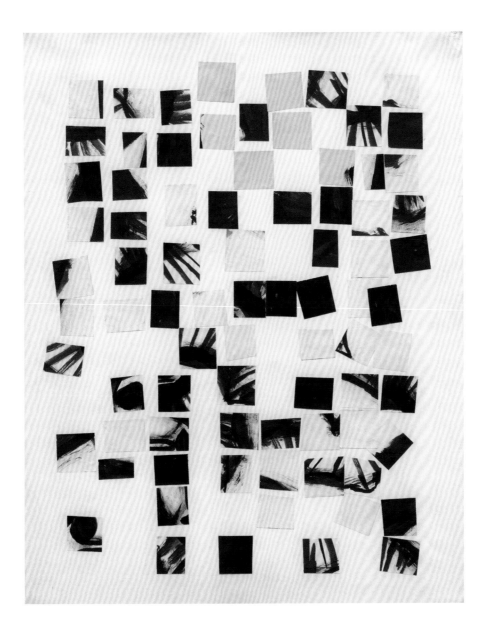

FIG. 15. Ellsworth Kelly (American, 1923–2015). *Cut Up Drawing Rearranged by Chance.* 1950. Ink and collage on paper, 25½ × 19½" (65 × 50 cm). GLENSTONE MUSEUM, POTOMAC, MARYLAND

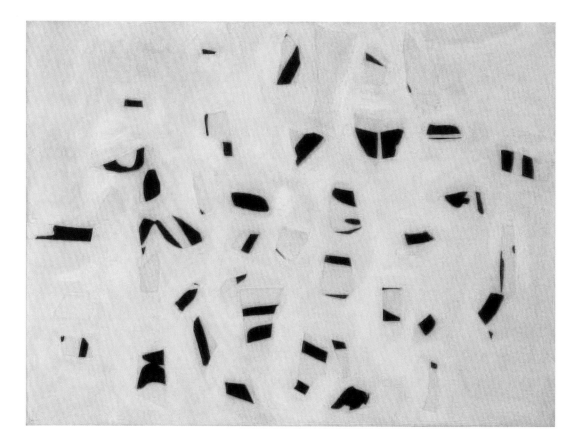

FIG. 16. Ellsworth Kelly (American, 1923–2015). *November Painting.* 1950. Oil on wood, 25½ × 34″ (64.8 × 86.4 cm). COLLECTION ELLSWORTH KELLY STUDIO AND JACK SHEAR, ON LONG-TERM LOAN TO THE PHILADELPHIA MUSEUM OF ART

random placement of each square and in the resulting patterns of fragmented ink brushstrokes."[31] *November Painting* was the only painting Kelly made using this method [FIG. 16]. "I dropped black and white fragments of paper onto a gessoed board and didn't do much arranging. It was a chance situation," Kelly explains. "It was like an explosion."[32]

———

For Kelly, works like *Cut Up Drawing Rearranged by Chance* and *November Painting* were not wholly satisfying. Chance, he learned, might be combined with other strategies, an experience that the city once again would spark.

 With his studio on Île Saint-Louis, a parallelogram of land in the middle of the Seine, Kelly traveled back and forth across the bridges that connected the island to Paris's Right and Left Banks. On these evening walks he was often struck by the reflections of the bridge's street lamps on the river. With the water in constant motion, the patterns of light and dark were ever changing. Kelly set out to capture what he saw. However, having by this time cast aside traditional forms of depiction and descriptive mark-making, this would be a challenge—and on top of that, up until then, many of his subjects were flat, static things. I "really liked this shimmering," Kelly explains, "but I didn't want to paint an Impressionist painting—a black river with white dots on it!"[33] The Impressionists' small dabs of color in varying hues that Kelly refers to as "dots" were a painterly description of shifting atmospheric qualities, including water in motion [FIG. 17]. Kelly set out to find another way. He began by making drawings, using a black medium on a creamy white ground. Such a simple choice paradoxically expressed the complexity of the endeavor: If light is shining on the water, does the light paper represent the illuminated patterns and the black lines, the dark unlit areas of water? Or does the black medium, counterintuitively, represent light, and the white paper the dark water? Kelly's drawings do not answer these questions, but instead express an ongoing optical tension.

 In his Seine drawings, Kelly tries out a variety of shapes, sizes, and scales (and a variety of papers as well) to explore reflections in motion. In some of these drawings, the gentle movement of the current is expressed by slender horizontal lines that evoke undulation. In another, repeating strokes transform the Seine into a tapestry [FIG. 18]. At times, to evoke sensations of pooling and dispersal, Kelly clusters his marks and then reduces their number as he moves further from the sheet's center. As easily changing as the patterns of light and dark that he observes are, they nonetheless seem to suggest to Kelly a kind of structure or a system: across the group of drawings we find repetitions, semiconsistent scatters, and armatures [FIG. 19]. Kelly's Seine drawings ultimately demonstrate the value of what will become a key element in his work—a systematic overall grid.

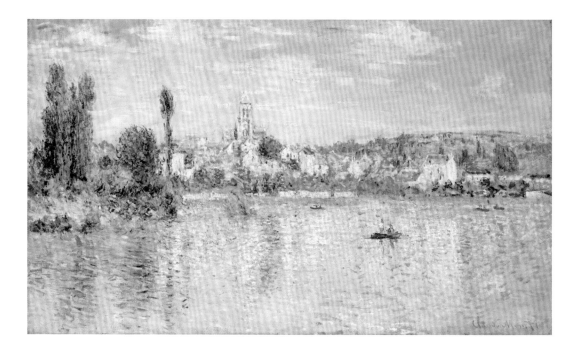

FIG. 17. Claude Monet (French, 1840–1926). *Vétheuil in Summer.* 1880. Oil on canvas, 23⅝ × 39¼″ (60 × 99.7 cm).
THE METROPOLITAN MUSEUM OF ART, NEW YORK. BEQUEST OF WILLIAM CHURCH OSBORN

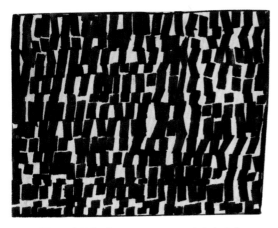

FIG. 18. Ellsworth Kelly (American, 1923–2015). *Light Reflection on Water*. 1950. Ink on paper, 2¼ × 2⅞" (5.7 × 7.3 cm) (irreg.). THE MUSEUM OF MODERN ART, NEW YORK. PROMISED GIFT OF KATHY AND RICHARD S. FULD, JR. IN HONOR OF ELLSWORTH KELLY ON THE OCCASION OF HIS 85TH BIRTHDAY

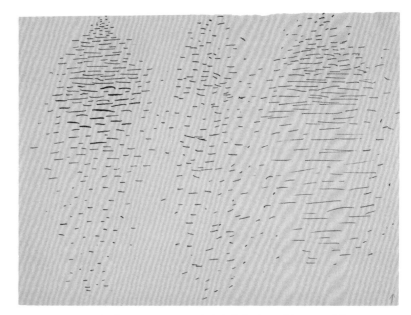

FIG. 19. Ellsworth Kelly (American, 1923–2015). *Light Reflection on Water*. 1950. Ink on paper, 6½ × 8⅝" (16.5 × 21.9 cm). PHILADELPHIA MUSEUM OF ART. IN HONOR OF THE 2023 ELLSWORTH KELLY CENTENNIAL. GIFT OF JACK SHEAR

Kelly uses the grid as an organizing principle in his painting *Seine* [FIG. 20], which represents the summation of these studies. Taken by the way the reflection on the river, "though denser at the center, appeared to be splintered at random by the wavelets," Kelly sought "to paint this without subjective interpretation," he told the artist and art historian George Rickey. Rickey meticulously recorded Kelly's working method on *Seine*:

> [He] divided the painting surface into forty equal parts vertically and eighty horizontally, and numbered this grid. Forty pieces of paper were placed in a box. Beginning with the left vertical column, one number was drawn from the box and marked to be painted black; the number then was returned to the box. Next, two numbers were drawn from the box for the second column; then three numbers for the third column and so on until all forty units (at the middle of the painting) were all black. This was then repeated beginning at the extreme right vertical column, working toward the center.[34]

Seine is both completely systematic and utterly evocative. The tension between what is light and what is dark, what is water and what is reflection, what is still and what is in motion, perfectly captures the nighttime experience of the river. (Ahead of his time, Kelly envisioned a pixelated field that speaks to our own digital world.)

With *Seine* Kelly combines two seemingly contradictory approaches: chance operations (whereby compositional decisions were made not by invention but by pulling numbers randomly out of a hat) and a system (the grid, a spatial order organized around parallel vertical and horizontal lines). Kelly's alliance of these opposites, called by some critics "modified" chance, represented a next step toward *Colors for a Large Wall.*

While the particular qualities of the river—its repeating waves suggest units that can be organized into a system—may have been factors in prompting Kelly's turn to the grid, those visits with Jean Arp continued to loom large. In the Arps' studio, Kelly saw examples of the couple's "duo-collages," created in 1918 [FIG. 21]. As was true for Kelly, the grid offered Arp and Taeuber-Arp a ready-made structure that eliminated individual agency and decision-making. And instead of tearing the papers by hand for these collaborative efforts, they used a paper cutter, all the better to provide an impersonal, mechanical edge.

Kelly then set a new problem for himself: how to introduce color? He was excited about the possibilities of a paper he had recently discovered that was used by French schoolchildren: *papier gommette,* or gummed paper. The product came in a variety of colors with one side brightly saturated, exuding extra vibrancy due to a surface shine, and the other coated with glue. When the glue

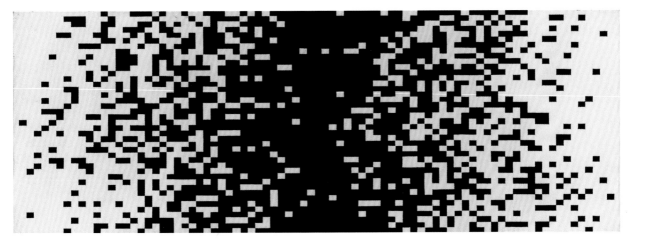

FIG. 20. Ellsworth Kelly (American, 1923–2015). *Seine.* 1951. Oil on wood, 16½ × 45¼″ (41.9 × 114.9 cm).
PHILADELPHIA MUSEUM OF ART. PURCHASED WITH FUNDS CONTRIBUTED IN MEMORY OF ANNE D'HARNONCOURT AND
OTHER MUSEUM FUNDS

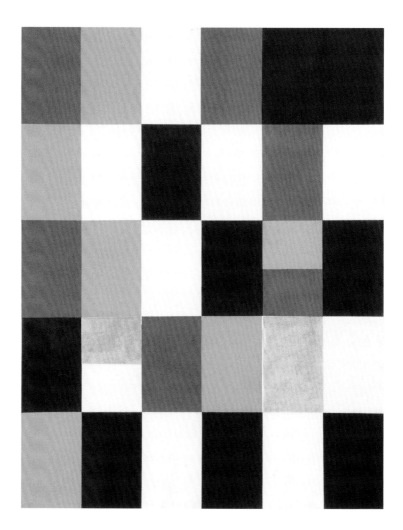

FIG. 21. Jean (Hans) Arp (French, born Germany [Alsace]). 1886–1966) and Sophie Taeuber-Arp (French, born Switzerland. 1889–1943). *Untitled (Duo-Collage).* 1918. Paper, board, and silver leaf on paperboard, 32⁵/₁₆ × 24⁷/₁₆″ (82 × 62 cm). NATIONALGALERIE, STAATLICHE MUSEEN ZU BERLIN. PERMANENT LOAN OF THE STATE OF BERLIN

(or gummed) side was dampened, the adhesive would be activated, allowing the paper to be stuck down. The papier gommette offered Kelly a wide-ranging and ready-made palette and thus removed personal preference from another aspect of aesthetic decision-making: his colors would be limited to those provided in the package. No mixing; nothing extra. And, so easy to glue down, it may have also encouraged Kelly's dive into collage.

With papier gommette as his primary medium, he launched into cutting and pasting, following (with some tweaks) the chance operations he had used for the painting *Seine*. For this new collage he joined two sheets of paper, which mimicked *Seine*'s oblong shape; and he drew the grid with fewer lines, each individual unit now a square instead of a rectangle **[FIG. 22]**. Trying out a new and yet more complicated approach here, Kelly adjusted his selection by making sure that the left and right sides of the collage were negatives of each other: if one were laid on top of the other, all the squares would be filled.[35] In the seven collages that followed, he moved away from *Seine*'s format, taking up a square structure. With the series title Spectrum Colors Arranged by Chance (1951), he announced his process while emphasizing that creative decisions were made without ego. Although Kelly had put a system into place—the collages share a one-inch grid and a similarity in size—he did not completely abdicate his agency. Instead, he asserted his authorial presence by slightly adjusting in each work how he would deploy chance and how closely he would adhere to the system. For some, he reduced the number of squares he pulled out of the hat as he moved away from the center; in others, the squares are scattered throughout, resulting in an allover arrangement akin to the warp and weft of a woven textile. **[FIG. 23]**.

Did Kelly use collage as a way to set new challenges for himself and try out ideas? Made of elements that are glued together, whether contiguous or overlapping and layered, collage's part-by-part arrangements may have encouraged Kelly's experimentation with single works made from multiple canvases or panels **[FIG. 24]**, as in *Colors for a Large Wall*. Collage allowed Kelly to consider each color separately, while also combining them. In the Spectrum series, for example, Kelly's cut-up squares are pure color, color that is color alone, without having the responsibility to represent or stand for something else. As an observer once wrote, Kelly's colors are "not something that is red and blue, but a red and blue that is something."[36]

———

After a full immersion in the time-consuming creation of the Spectrum collages, Kelly had used up most of his stash of papier gommette. In November 1951, he departed Paris for an extended stay in the fishing village of Sanary-sur-Mer, on France's southern coast, bringing a small envelope holding fewer than eighty

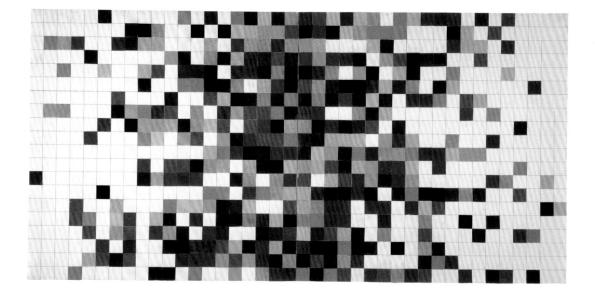

FIG. 22. Ellsworth Kelly (American, 1923–2015). *Spectrum Colors Arranged by Chance I.* 1951. Cut-and-pasted color-coated paper and pencil on two joined sheets of paper, 19½ × 39″ (49.5 × 99.1 cm). PHILADELPHIA MUSEUM OF ART. PURCHASED WITH FUNDS CONTRIBUTED BY C. K. WILLIAMS, II (BY EXCHANGE)

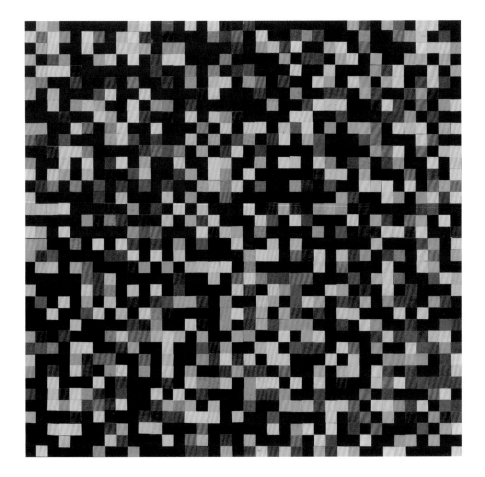

FIG. 23. Ellsworth Kelly (American, 1923–2015). *Spectrum Colors Arranged by Chance VI.* 1951. Cut-and-pasted color-coated paper and pencil on four sheets of black paper, 37 ¼ x 37 ¼" (94.6 x 94.6 cm). THE MUSEUM OF MODERN ART, NEW YORK. PURCHASED WITH FUNDS PROVIDED BY THE EDWARD JOHN NOBLE FOUNDATION, THE HERBERT AND NANETTE ROTHSCHILD FUND, AND MRS. PIERRE MATISSE

FIG. 24. Ellsworth Kelly (American, 1923–2015). *Painting for a White Wall.* 1952. Oil on canvas, five joined panels, 23⅝ × 71¼" (60 × 181 cm). GLENSTONE MUSEUM, POTOMAC, MARYLAND

squares, now with the range of available colors much reduced. After completing another gridded collage, he was left with only thirty-six squares representing thirteen colors: three shades of blue, two shades of green, and two shades of purple, along with brown, orange, yellow, pink, red, and black.

Such a limited number and a limited palette was its own kind of chance, a given that Kelly accepted as he embarked on the collage that would be used to create *Colors for a Large Wall.* He settled on an eight-by-eight grid of squares— perhaps accepting another readymade: the checkerboard. Knowing that he only had thirty-six squares on hand and sixty-four slots to fill, Kelly must have realized that white (that is, no color) would be a dominant presence in the final work.

Kelly started by drawing a grid with sixty-four squares on a square sheet of paper. According to Bois, the locations for the black squares were likely determined first. Kelly then dispersed the rest of the colors, "very, very quickly, without thinking."[37] In the final composition no two adjacent panels are the same color [**FIG. 25**].

Having created this modest collage by means of his now well-practiced anti-authorial methods—accepting ready-made colors that were also randomly generated leftovers (and perhaps acceding to the format of the checkerboard too); determining the placement of colors "without thinking"; and modifying those chance procedures through the use of a system (the organizational principle of the

grid and the order in which the colors would be selected)—Kelly took yet another step in translating the study to what would become the final work, *Colors for a Large Wall*. How to capture the collage in a painting at first "perplexed him."[38] Realizing that "a painted or drawn grid is still a depiction of sorts,"[39] he began to imagine how each painted color could maintain the integrity of a cut-paper square. Luckily, he lived just upstairs from a cabinetmaker, who, upon Kelly's request, constructed sixty-four separate stretchers for sixty-four separate canvases. Each would be painted with a single color to match the corresponding square in the collage. Thus, the resulting work was not a painting of a grid but a grid itself—a grid of individual parts that together form a whole. Kelly explains:

> If I had painted the 64 panels on one canvas it would have been quite a different painting, reminiscent of a Klee or a Mondrian. But I wanted an edge for each color, I wanted it to begin and to end so that it had its own uniqueness. Like everything has its own uniqueness in this room where we are, in the world, every object/form has its edges. If you copy it, you depict it, and that I knew: I didn't want to depict. In order not to depict I had to make the panels. They play the role of those specific shapes I see, they don't represent them.[40]

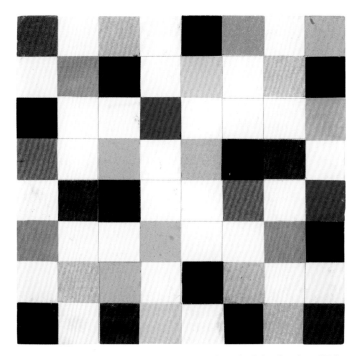

FIG. 25. Ellsworth Kelly (American, 1923–2015). *Study for Colors for a Large Wall.* 1951. Cut-and-pasted color-coated paper and pencil on paper, 7⅞ × 7¾" (20 × 19.7 cm). COLLECTION ELLSWORTH KELLY STUDIO AND JACK SHEAR

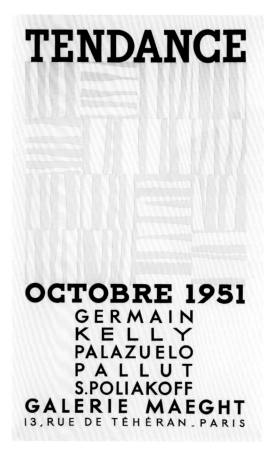

For a young artist who was constantly moving studios, there was a practical benefit as well: the modular elements could be taken apart, stacked up, and stored away.[41]

Committed to the papier gommette's ready-made color, Kelly spent a significant amount of time mixing paints to match the paper color as closely as possible—all to further remove his personal decision-making. A flat application also mimicked the surface of the paper, while completely eliminating gesture. (It should be noted that he did not try to reproduce the paper's shine.) For Kelly, flat application was key to rid the canvas itself of any trace of the hand. But "the 'line' or the 'drawing'" remain, "becom[ing] the 'literal' edge of the panels," and that drawing opens up the possibilities of a relationship with the wall on which the painting hangs.[42] Acknowledging the new status of this work, Kelly describes it thus: "A painting in sixty-four panels, the first painting of multiple panels, in which each panel is only one color. There is neither form nor ground in the painting. The painting is the form and the wall is the ground . . . a work midway between painting and sculpture."[43]

What of the work's title, *Colors for a Large Wall*? Kelly first referred to it as "64 Panels," but by 1952—just a year after it was completed, when it debuted in the group exhibition *Tendance* at Paris's Galerie Maeght [**FIG. 26**]—it was presented with its current name. We have already seen the role of colors in this work, but what about the title's second part? It is more instruction than description, telling us where the work belongs: it is meant "for a large wall."

The work itself is certainly large—the biggest Kelly had made up until that point—and the picture "would have been larger, the artist has said many times, if not for the constraints of exhibition space," with each square "as tall as human scale."[44] But as substantial as this work is (at close to eight feet square, taller than a tall person, wider than Michael Phelps's wingspan), the word "large" in Kelly's title doesn't indicate a size easily measured with a ruler. In referring to a "large wall," Kelly expresses something aspirational: "large" for Kelly is synonymous with "public" and expresses his ambition for his art to play a role in the public sphere.

———

Art's public presence had piqued Kelly's imagination since his student days. At Boston's Museum School, he had encountered the ideas of Herbert Read, an art historian who lectured on abandoning domestically scaled easel painting in favor of public art.[45] Those ideas stuck with Kelly as he experienced France's architectural monuments, both during and after the war, and saw the impact of churches, monasteries, and cathedrals—and their ruins—on villages, cities, and landscapes. And in that context of discovery, Kelly colorfully lays out his own aspirations in a letter written in 1950 to the composer John Cage[46], with whom Kelly had struck up a friendship early on in his Paris years:

> My collages are only ideas for things much larger—things to cover walls. In fact all the things I've done I would like to see much larger. I am not interested in painting as it has been accepted for so long—to hang on the walls of houses as pictures. To hell with pictures—they should be the wall—even better—on the outside wall—of large buildings.[47]

Kelly formalized these ideas the following year, just as he was completing *Colors for a Large Wall*, in a grant proposal to the John Simon Guggenheim Memorial Foundation. Perhaps surprisingly, his large-scale ideas about the civic role of art's future would be formulated in the most intimate of objects, a book, "the size . . . approximately 8" x 10"." In "Project for a Book: Line, Form and Color," Kelly writes, "I propose to create a book which will be an alphabet of plastic pictorial elements, aiming to establish a new scale of painting, a closer contact between the artist and the wall, providing a way for painting to accompany modern architecture."[48]

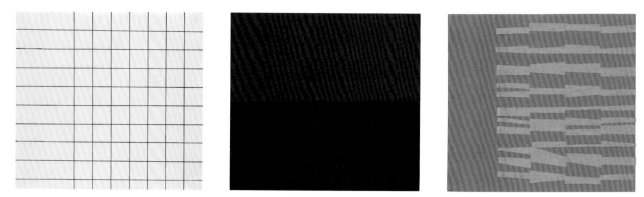

FIG. 27 A–C. Ellsworth Kelly (American, 1923–2015). *Grid Lines, Blue and Red,* and *Pink and Orange,* from the series Line Form Color. 1951. Ink on paper; color-coated paper (two overlapping sheets); and cut-and-pasted color-coated paper on color-coated paper, respectively; each: 7½ × 8″ (19 × 20.3 cm). THE MUSEUM OF MODERN ART, NEW YORK. GIFT OF THE ARTIST AND PURCHASED WITH FUNDS PROVIDED BY JO CAROLE AND RONALD S. LAUDER, SARAH-ANN AND WERNER H. KRAMARSKY, MR. AND MRS. JAMES R. HEDGES, IV, KATHY AND RICHARD S. FULD, JR., AND COMMITTEE ON DRAWINGS FUNDS

While Kelly was not successful in his grant application—and the book was not published then—the project's maquettes show that, despite its small scale, the book created a world, filling the reader's visual field with linear dances, dynamic shapes, and saturated color [**FIGS. 27 A–C**].

In the early 1950s Kelly wrote to Hilla Rebay, the founder of the Museum of Non-Objective Painting (now the Solomon R. Guggenheim Museum in New York), "I believe that the days of the 'easel' painting are fading, and that the future art will be something more than just 'personality paintings' for walls of apartments and museums. The future art must go to the wall itself. And this is what I have been trying to do in my work."[49] That sentiment was already part of his thinking for *Colors for a Large Wall.* In response to a MoMA questionnaire, Kelly wrote, "The title refers to a much larger version—a 'mural' for a much larger wall than the wall space needed for this painting."[50] How a mural with similar elements might have looked if given the opportunity to stretch horizontally can be found in the collage *Study for a Mural in a Hundred Panels* [**FIG. 28**].

Kelly would use the phrase "for a large wall" in a number of subsequent pieces, continuing to remind viewers of his ambition to create a public art—and emphasizing the relationship of work to wall, that the wall plays a role in a work's presence. The first of these was the 1957 *Sculpture for a Large Wall,* a commission for Philadelphia's Penn Center Transportation Building. The sixty-five-foot-long, eleven-foot-tall relief is made of 104 colorful, shaped-metal panels mounted on an armature comprised of five rows of parallel rods. The red, blue, black, yellow, gold, and silver panels hang at different angles from one horizontal bar to the next,

as if they are in conversation, leaning into each other or pulling away [**FIG. 29**]. Rendered in anodized aluminum, the shapes have the lightness of paper; despite its large size, the whole sculpture offers the sense that it might be easily folded up and stashed away. Shadows created by the bars and plates bring the wall into the composition. "After Paris," Kelly said, "I thought I had exhausted what the painting in panels could express, so I started with painted curves." He soon began to see the possibilities of shapes existing on their own: "A short while later, I cut it out in metal, let it exist for itself."[51]

As much as *Sculpture for a Large Wall* seemed to answer Kelly's "craving for the mural scale," the large relief still maintained a separation between work and wall.[52] It was about twenty years later, in 1978, with *Color Panels for a Large Wall*, that he would have the opportunity to more fully incorporate the wall into his composition. According to Kelly, the spark for this work was *Colors for a Large Wall*: the CEO of Cincinnati's Central Trust Company, Oliver Birckhead, saw the painting during a visit to MoMA and had phoned Kelly to invite him to make a mural "in the same spirit for their new bank lobby."[53] Like *Colors for a Large Wall*, the "Cincinnati Mural," as Kelly originally called it, would consist of a group of monochrome panels, this time significantly larger at forty-eight by sixty-eight and a half inches. Instead of joining them into a single armature as he did in the prior work, Kelly arrayed the panels across the bank building's lobby in a configuration of nine vertical pairs [**FIG. 30**]. Spanning more than 125 feet and mounted above the tellers' workstations, they seem to push against the bounds of the building while being wholly framed by it. Kelly explained that the work would be "big enough so that you won't see it all at once without turning your head. I want the wall to be a continuous experience for the viewer and not have a beginning or an end."[54] "The design, color and measure of the wall are very important to me," Kelly insisted. "It is the ground on which the

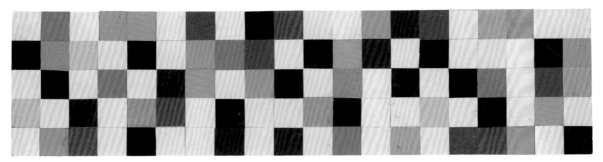

FIG. 28. Ellsworth Kelly (American, 1923–2015). *Study for a Mural in a Hundred Panels.* 1951. Cut-and-pasted color-coated paper and pencil on paper, 4⅞ × 19⅝" (12.4 × 49.8 cm). THE MUSEUM OF MODERN ART, NEW YORK. IN HONOR OF THE 2023 ELLSWORTH KELLY CENTENNIAL. GIFT OF JACK SHEAR

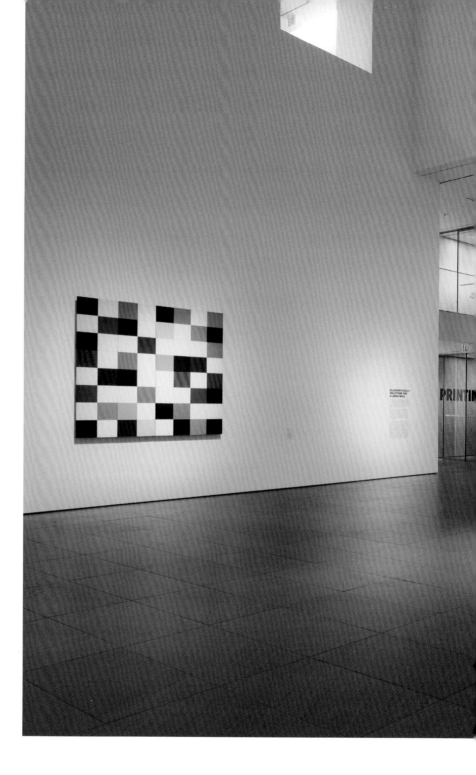

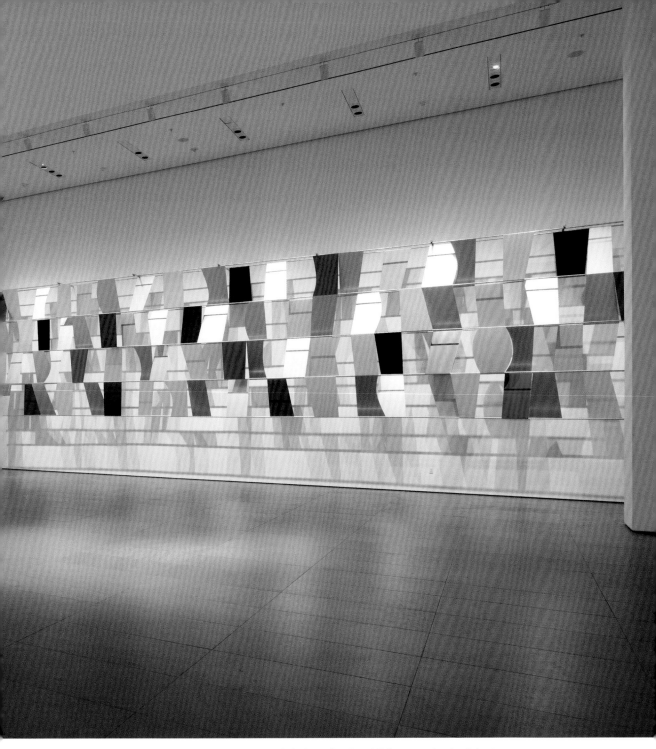

FIG. 29. Ellsworth Kelly (American, 1923–2015). *Sculpture for a Large Wall*. 1956–57. Anodized aluminum, 104 panels, 11′ 5″ × 65′ 5″ × 28″ (348 × 1994 × 71.1 cm). THE MUSEUM OF MODERN ART, NEW YORK. GIFT OF JO CAROLE AND RONALD S. LAUDER

At left: *Colors for a Large Wall*

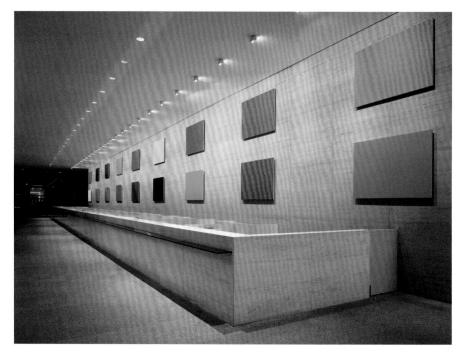

FIG. 30. Ellsworth Kelly (American, 1923–2015). *Color Panels for a Large Wall*. 1978. Oil on canvas, eighteen panels; overall: 10' × 125' 8½" (305 × 3831 cm). Installation view, Central Trust Center, Cincinnati, 1979

panels must work."[55] The interstitial spaces between the panels are as much a part of the composition as the panels themselves. Made of travertine, a tan limestone, the wall has a warmth that Kelly embraced. A white wall, he said, "is too neutral, like light. You tend to read it out of the work."[56] Instead, Kelly wanted viewers to read the wall *into* the work.

While we might be inclined to consider this work "site-specific"—designed specifically for its Cincinnati location and that travertine wall—Kelly was interested in trying out his approach in varied places. With his permission, over the years *Color Panels for a Large Wall* appeared in exhibitions in Amsterdam, New York, and Munich, and when the bank building was undergoing a renovation, the work was given first to the Cincinnati Art Museum and then later reconfigured for its current location, the taller, squarer north wall of the National Gallery of Art's East Building atrium, in Washington, DC. Ever interested in exploring the panels' relationship with their surroundings, Kelly rethought his composition based on these new proportions, setting aside his "twins" for "triplets" **[FIG. 31]**. At the time of its reconfiguration, Kelly remarked, "It looks much better this way. It seems like it's expanding. The panels cover the entire wall.... I always dreamed

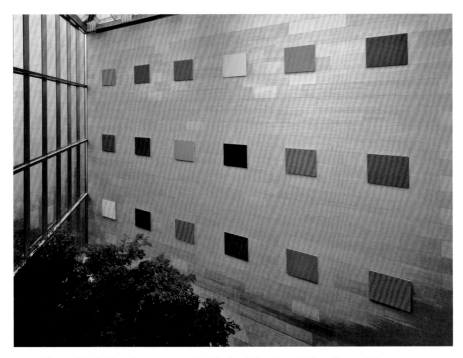

FIG. 31. Ellsworth Kelly (American, 1923–2015). *Color Panels for a Large Wall*. 1978/2003. Oil on canvas, eighteen panels; overall: 54′ × 90′ (1646 × 2743 cm). NATIONAL GALLERY OF ART, WASHINGTON, DC. PURCHASED WITH FUNDS PROVIDED BY THE GLENSTONE FOUNDATION

about doing them, even when I was very young. And this is the culmination of all my panels."[57]

Even as the monochrome panels encourage a sense of unity, to borrow Kelly's term, across the space of the National Gallery's lobby, they remain objects that are created "for a wall." It was only when Kelly had the chance to envision an actual work of free-standing architecture that he could fully integrate color into the wall itself. In 1986 he was invited to design a chapel for a private residence. While the chapel was not realized then, it was eventually built in 2015, on the campus of the University of Texas at Austin, overseen by the Blanton Museum of Art and titled *Austin*.[58] Kelly planned the overall structure, chose the materials, and designed the interior and exterior details. In a double barrel-vaulted structure of light gray limestone that relates to the Romanesque churches he had seen in France, Kelly embedded sheets of stained-glass directly into the walls, in three compositions: on the east wall a circle of twelve "tumbling" squares representing the color spectrum; on the west wall a ring of colorful rods representing that same spectrum; and over the entrance door a grid of nine colored squares **[FIG. 32]**. The monochromatic panels of flatly rendered oil paint that remained the central vocabulary of Kelly's

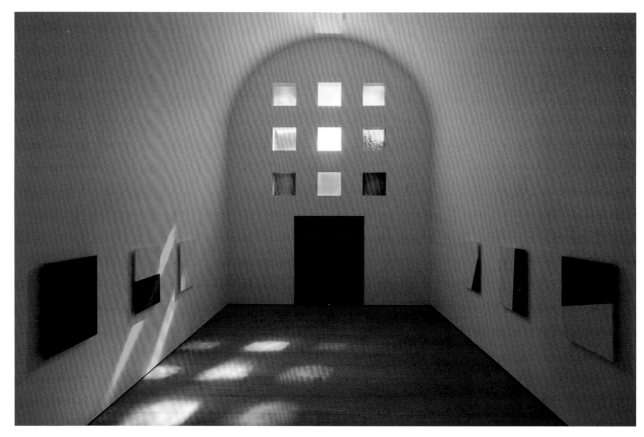

FIG. 32. Ellsworth Kelly (American, 1923–2015). *Austin.* 2018. Austin, Texas. BLANTON MUSEUM OF ART, THE UNIVERSITY OF TEXAS AT AUSTIN. GIFT OF THE ARTIST AND JACK SHEAR, WITH FUNDING GENEROUSLY PROVIDED BY JEANNE AND MICHAEL KLEIN, JUDY AND CHARLES TATE, THE SCURLOCK FOUNDATION, SUZANNE DEAL BOOTH AND DAVID G. BOOTH, AND THE LONGHORN NETWORK. ADDITIONAL FUNDING PROVIDED BY THE BROWN FOUNDATION, INC. OF HOUSTON, LESLIE AND JACK S. BLANTON, JR., ELIZABETH AND PETER WAREING, SALLY AND TOM DUNNING, THE LOWE FOUNDATION, THE EUGENE MCDERMOTT FOUNDATION, STEDMAN WEST FOUNDATION, AND THE WALTON FAMILY FOUNDATION, WITH FURTHER SUPPORT PROVIDED BY SARAH AND ERNEST BUTLER, BUENA VISTA FOUNDATION, THE RONALD AND JO CAROLE LAUDER FOUNDATION, EMILY RAUH PULITZER, JANET AND WILSON ALLEN, JUDY AND DAVID BECK, KELLI AND EDDY S. BLANTON, CHARLES BUTT, MRS. DONALD G. FISHER, AMANDA AND GLENN FUHRMAN, GLENSTONE/EMILY AND MITCH RALES, STEPHANIE AND DAVID GOODMAN, AGNES GUND, STACY AND JOEL HOCK, LORA REYNOLDS AND QUINCY LEE, HELEN AND CHUCK SCHWAB, ELLEN AND STEVE SUSMAN, AND OTHER DONORS

work for more than fifty years are here transformed into luminous stained-glass, offering up the color of light itself. No longer "for a large wall," the colors are part of the wall itself. And as the light moves and changes through the day, the colors dance across walls and floor and the shapes dissolve and liquify. With *Austin*, Kelly created an art that "go[es] to the wall itself,"[59] extending the ambitions so boldly declared in *Colors for a Large Wall.*

NOTES

I am deeply grateful to the many scholars whose research and writing have illuminated Kelly's practice; their indispensable publications are listed in For Further Reading and cited in the notes below. On the artist's journey to making *Colors for a Large Wall*, I am particularly indebted to the scholarship and generosity of Yve-Alain Bois, who first set out the trajectory of Kelly's time in France described here, Tricia Y. Paik, and Ann Temkin. Many thanks to the expert team at the Ellsworth Kelly Studio and much gratitude to Jack Shear for his unwavering support.

1. Kelly, in Anna Somers Cocks, "Interview with Ellsworth Kelly: 'The Freedom of Colours in Space,'" *Art Newspaper*, May 31, 2008, theartnewspaper.com/2008/06/01/interview-with-ellsworth-kelly-the-freedom-of-colours-in-space.

2. Kelly, quoted in Tricia Y. Paik, *Ellsworth Kelly* (New York: Phaidon, 2015), 11.

3. Kelly, quoted in Philip Gerard, *Secret Soldiers: The Story of World War II's Heroic Army of Deception* (New York: Dutton, 2002), 63.

4. Kelly, quoted in Ann Temkin, "Ellsworth Kelly," *Artforum* 54, no. 8 (April 2016), artforum.com/print/201604/ann-temkin-58709.

5. Kelly, in Somers Cocks.

6. Rick Beyer and Elizabeth Sayles, *The Ghost Army of World War II* (New York: Princeton Architectural Press, 2015), 104.

7. Kelly, quoted in Nathalie Brunet, "Chronology, 1943–1954," in Yve-Alain Bois, Jack Cowart, and Alfred Pacquement, *Ellsworth Kelly: The Years in France, 1948–1954*, exh. cat. (Washington, DC: National Gallery of Art, 1992), 178.

8. Yve-Alain Bois, "Ellsworth Kelly's Dream of Impersonality," *The Institute Letter* (Fall 2013), Institute for Advanced Study, Princeton, NJ, ias.edu/ideas/2013/bois-ellsworth-kelly.

9. Kelly, in Paul Cummings, "Interview: Ellsworth Kelly talks with Paul Cummings," *Drawing* 13 (September–October 1991): 58.

10. Kelly, in Paul Taylor, "Ellsworth Kelly: Interview," *Artstudio* 24 (Spring 1992): 155.

11. Jack Cowart, "Method and Motif: Ellsworth Kelly's 'Chance' Grids and His Development of Color Panel Paintings, 1948–1951," in Bois et al., *The Years in France*, 39.

12. Jean-Paul Sartre, "The Search for the Absolute," introduction to *Exhibition of Sculpture, Paintings, Drawings* [of Alberto Giacometti], exh. cat. (New York: Pierre Matisse Gallery, 1948), 4.

13. Bois, "Ellsworth Kelly's Dream of Impersonality."

14. Gerard, *Secret Soldiers*, 261–62.

15. Bois, "Ellsworth Kelly's Dream of Impersonality."

16. Kelly, in Cummings, 57.

17. Bois, "Anti-Composition," in Bois et al., *The Years in France*. Naming of the strategies on p. 10; discussed throughout the text.

18. Yve-Alain Bois, introduction to *Ellsworth Kelly: Catalogue Raisonné of Paintings, Reliefs, and Sculpture, Vol. 1, 1940–1953* (Paris: Cahiers d'Art, 2015), 12.

19. Bois, "Ellsworth Kelly's Dream of Impersonality" and Brunet, 178.

20. Kelly, in Ann Hindry, "Conversation with Ellsworth Kelly," *Artstudio* 24 (Spring 1992): 22.

21. Kelly, in Hindry, 22.

22. Kelly, quoted in Brunet, 181.

23. Kelly, quoted in Paik, 31–32.

24. Kelly, in Taylor, 102.

25. Kelly's eye as a viewfinder and his photographs are discussed in Christine Mehring, *Color Panels for a Large Wall*, exh. cat. (New York: Matthew Marks Gallery, 2018), 36.

26. Kelly, in Cummings, 58.

27. Kelly, in Cummings, 58.

28. Kelly, "Notes of 1969," in Kristine Stiles and Peter Selz, *Theories and Documents of Contemporary Art: A Sourcebook of Artists' Writings* (Berkeley: University of California Press, 1996), 92.

29. Kelly describes his interest in the Surrealists' automatic drawing in Cummings, 59.

30. Bois, *Catalogue Raisonné of Paintings*, 224.

31. Ellsworth Kelly, *Artist's Choice: Ellsworth Kelly, Fragmentation and the Single Form*, exh. brochure (New York: The Museum of Modern Art, 1990), n.p.

32. Kelly, in Cummings, 59.

33. Kelly, in Hindry, 27.

34. George Rickey, quoted in Bois, *Catalogue Raisonné of Paintings*, 226.

35. The approach here and throughout the series Spectrum Colors Arranged by Chance is discussed in Bois, *Catalogue Raisonné of Paintings*, 262–67.

36. Unidentified reporter, quoted in Mehring, 29.

37. Kelly, quoted in Ann Temkin, *Color Chart: Reinventing Color, 1950 to Today*, exh. cat. (New York: The Museum of Modern Art, 2008), 47.

38. Temkin, *Color Chart*, 47.

39. Bois, *Catalogue Raisonné of Paintings*, 272.

40. Kelly, in Hindry, 28. *Colors for a Large Wall* was originally mounted on sixty-four separate stretchers; in the mid-1960s the sixty-four canvases were restretched on solid wood panels, as they remain today.

41. Temkin, *Color Chart*, 47

42. Kelly, quoted in Roberta Bernstein, "Ellsworth Kelly's Multipanel Paintings," in *Ellsworth Kelly: A Retrospective*, exh. cat. (New York: Guggenheim Museum, 1996), 42.

43. Kelly, quoted in Brunet, 192.

44. First quote: Yve-Alain Bois, *Ellsworth Kelly: The Early Drawings, 1948–1955*, exh. cat. (Cambridge, MA: Harvard University Art Museums, 1999), 28. Second quote (also from Bois, recounting what he heard from Kelly): *Catalogue Raisonné of Paintings*, 272–73.

45. Discussed in Brunet, 178, and Paik, 24.

46. Cage also famously embraced chance strategies, but according to Kelly it was not a topic they ever discussed.

47. Kelly, quoted in Brunet, 187–88.

48. Ellsworth Kelly, "Project for a Book: Line, Form and Color" (1951), in Ellsworth Kelly, *Line Form Color* (Cambridge, MA: Harvard University Art Museums, 1999), n.p.

49. Kelly to Hilla Rebay, November 29 [1952?], quoted in Michael Plante, "'Things to Cover Walls': Ellsworth Kelly's Paris Paintings and the Tradition of Mural Decoration," *American Art* 9, no. 1 (Spring 1995): 43n14.

50. Kelly, MoMA Object Questionnaire, *Colors for a Large Wall* (1951), December 15, 1976, object file, Department of Painting and Sculpture, The Museum of Modern Art, New York.

51. Kelly, quoted in Hindry, 32.

52. Bois, *The Early Drawings*, 28.

53. Kelly, MoMA Object Questionnaire, *Study for Painting in Eighteen Panels* (1978), September 12, 2007, object file, Department of Drawings and Prints, The Museum of Modern Art, New York.

54. Kelly, quoted in Mehring, 43.

55. Kelly, quoted in Mehring, 18.

56. Kelly, quoted in Mehring, 18.

57. Kelly, quoted in Carol Vogel, "Miró Tapestry Ending its Reign," *New York Times*, March 21, 2003, nytimes.com/2003/03/21/arts/inside-art.html. "Triplets" is curator Jeffrey Weiss's word, quoted in Mehring, 67. Similar to the walls at the original location, the museum's marble interior has a tone, a lavender-pink color.

58. For an overview of *Austin*, see the Blanton Museum of Art online resource: blantonmuseum.org/chapter/introduction-13/.

59. Kelly to Rebay.

FOR FURTHER READING

Bois, Yve-Alain. *Ellsworth Kelly: Catalogue Raisonné of Paintings, Reliefs, and Sculpture, Vol. 1, 1940–1953*. Paris: Cahiers d'Art, 2015.

Bois, Yve-Alain, Jack Cowart, and Alfred Pacquement. *Ellsworth Kelly: The Years in France, 1948–1954*. Exh. cat. Washington, DC: National Gallery of Art, 1992.

Kelly, Ellsworth. *Artist's Choice: Ellsworth Kelly, Fragmentation and the Single Form*. Exh. brochure. New York: The Museum of Modern Art, 1990; moma.org/documents/moma_catalogue_1697_300062981.pdf?_ga=2. 13077311.942033101.1687194729-768499324.1606999796.

Mehring, Christine. *Color Panels for a Large Wall*. Exh. cat. New York: Matthew Marks Gallery, 2019.

Paik, Tricia Y. *Ellsworth Kelly*. New York: Phaidon, 2015.

Temkin, Ann. *Color Chart: Reinventing Color, 1950 to Today*. Exh. cat. New York: The Museum of Modern Art, 2008.

Waldman, Diane, ed. *Ellsworth Kelly: A Retrospective*. Exh. cat. New York: Guggenheim Museum, 1996.

ALSO OF INTEREST

Beyer, Rick, and Elizabeth Sayles. *The Ghost Army of World War II*. New York: Princeton Architectural Press, 2015.

Gerard, Philip. *Secret Soldiers: The Story of World War II's Heroic Army of Deception*. New York: Dutton, 2002.

Leadership support for this publication is provided by The Jo Carole Lauder Publications Fund of The International Council of The Museum of Modern Art.

Produced by the Department of Publications,
The Museum of Modern Art, New York

Leadership support for this publication is provided
by The Jo Carole Lauder Publications Fund of
The International Council of The Museum of Modern Art.

Hannah Kim, Business and Marketing Director
Don McMahon, Editorial Director
Curtis R. Scott, Associate Publisher

Edited by Don McMahon
Series designed by Miko McGinty and Rita Jules
Layout by Amanda Washburn
Production by Matthew Pimm
Proofread by Sophie Golub
Printed and bound by Ofset Yapımevi, Istanbul

This book is typeset in Ideal Sans.
The paper is 150gsm Magno Satin.

Published by The Museum of Modern Art
11 West 53 Street
New York, NY 10019-5497
www.moma.org

ISBN: 978-1-63345-156-8

Distributed in the United States and Canada by
ARTBOOK | D.A.P.
75 Broad Street
Suite 630
New York, NY 10004
www.artbook.com

Distributed outside the United States and Canada by
Thames & Hudson
181A High Holborn
London WC1V 7QX
www.thamesandhudson.com

Printed and bound in Turkey